Elephant

Lion

Tiger

Bear

Rhino

Parrot

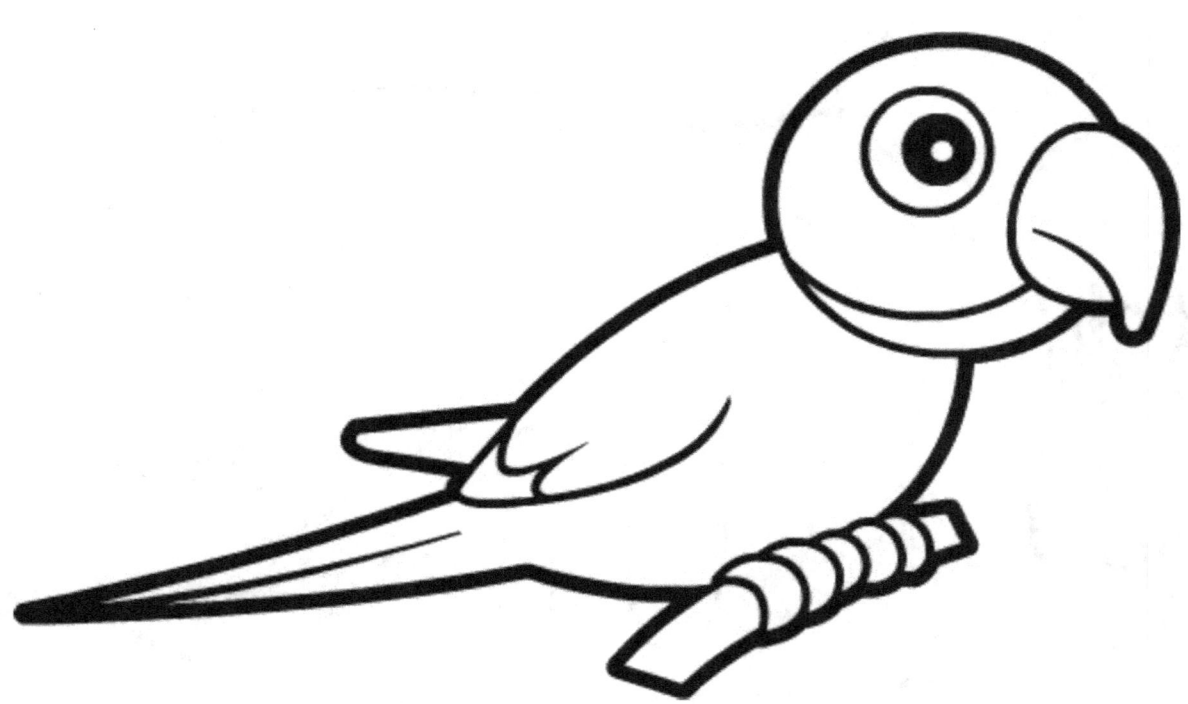

Crow

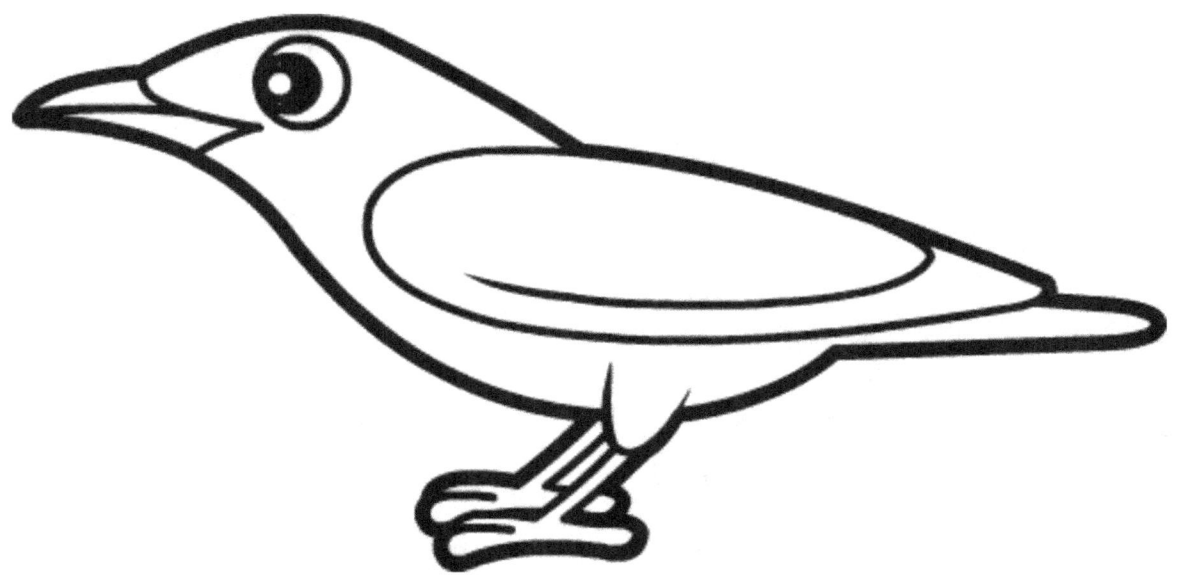

Eagle

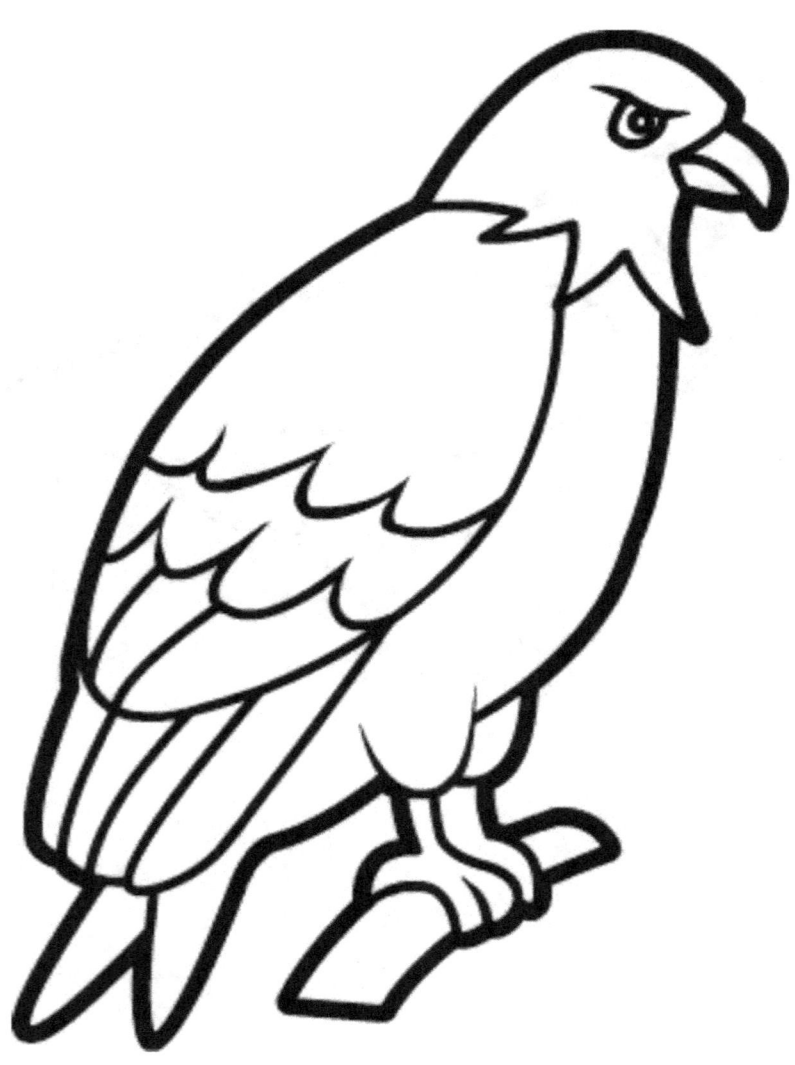

Owl

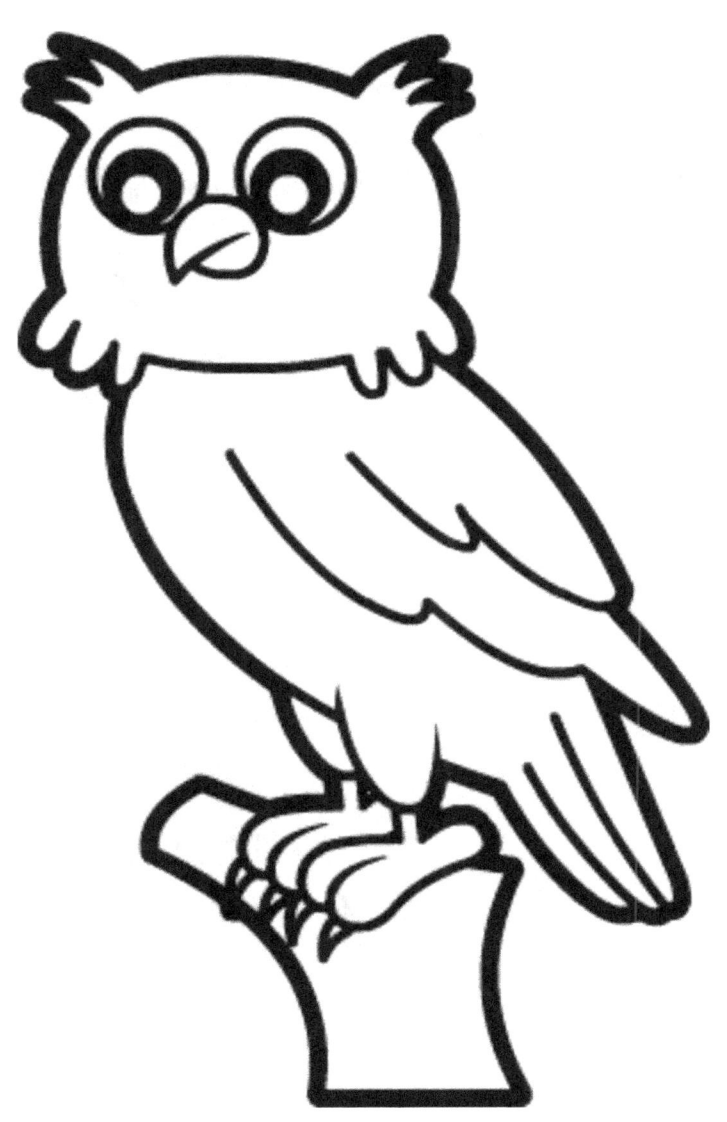

Kingfisher

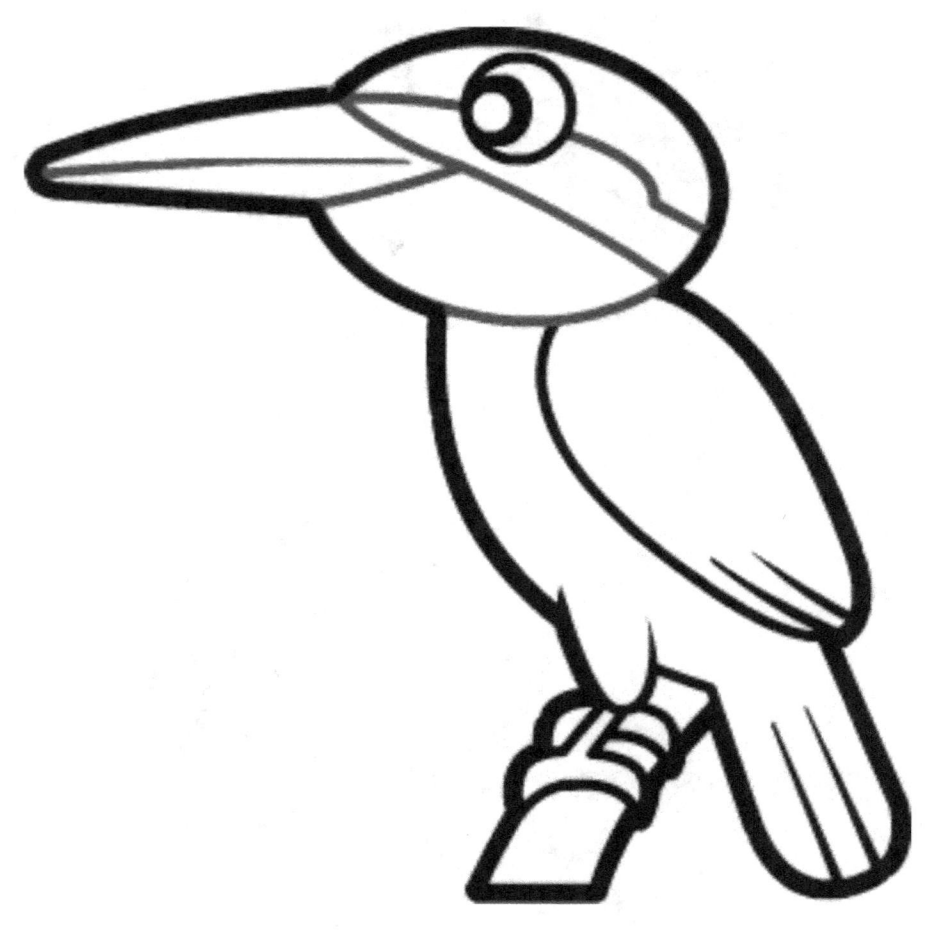

Orchid

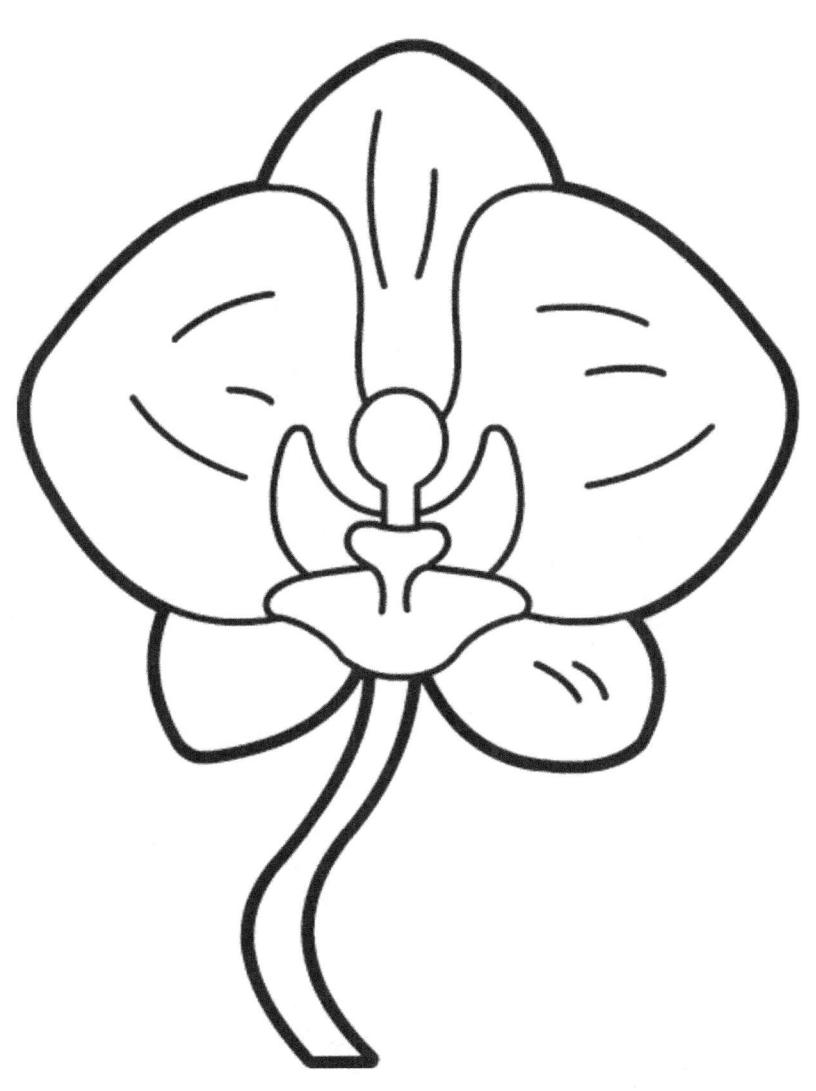

Temple

Lilly

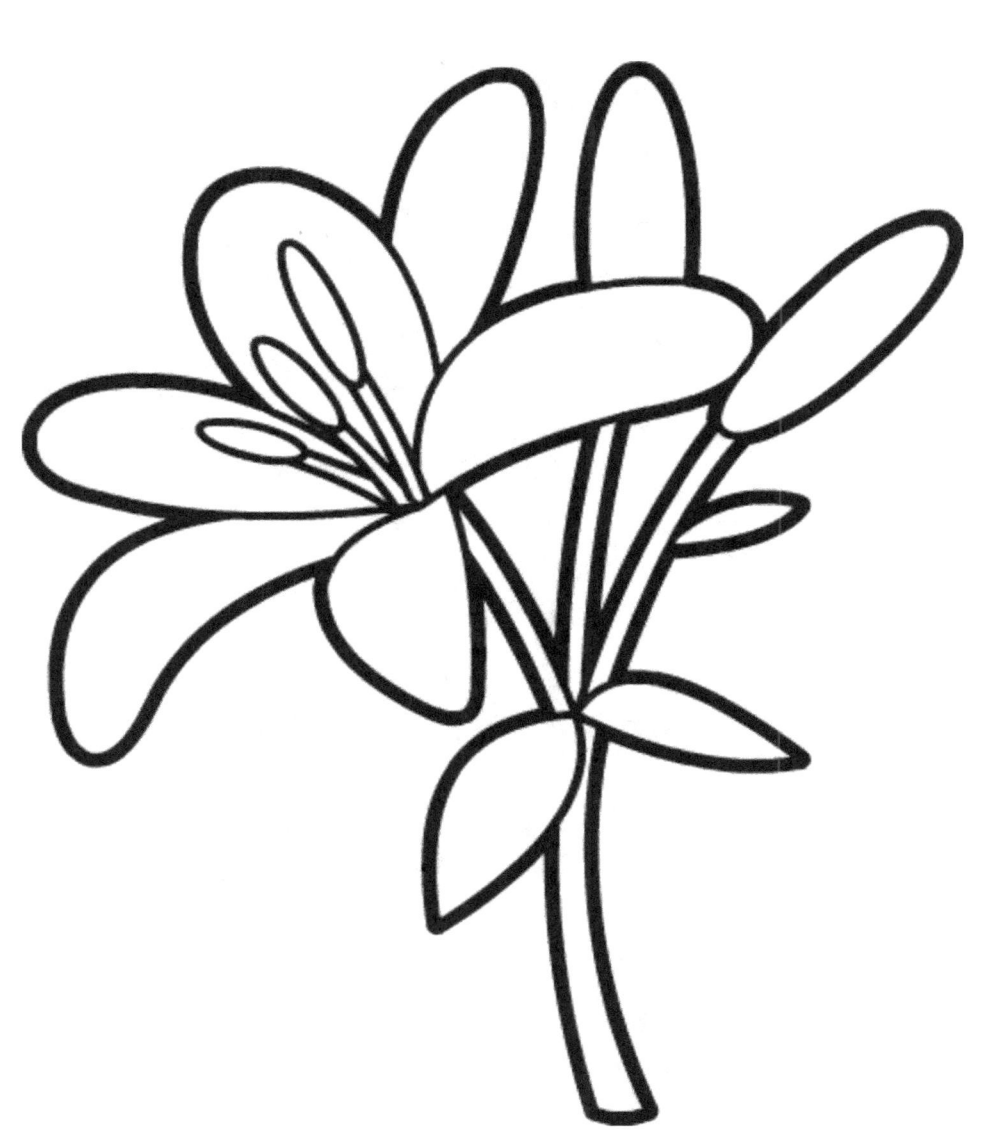

Rose

Lotus

Camera

Chair

Mug

Laptop

Tv

Bus

Bike

Car

Van

Rail

Eagle

Crow

Parrot

Kingfisher

Owl

Laptop

Tv

Camera

Chair

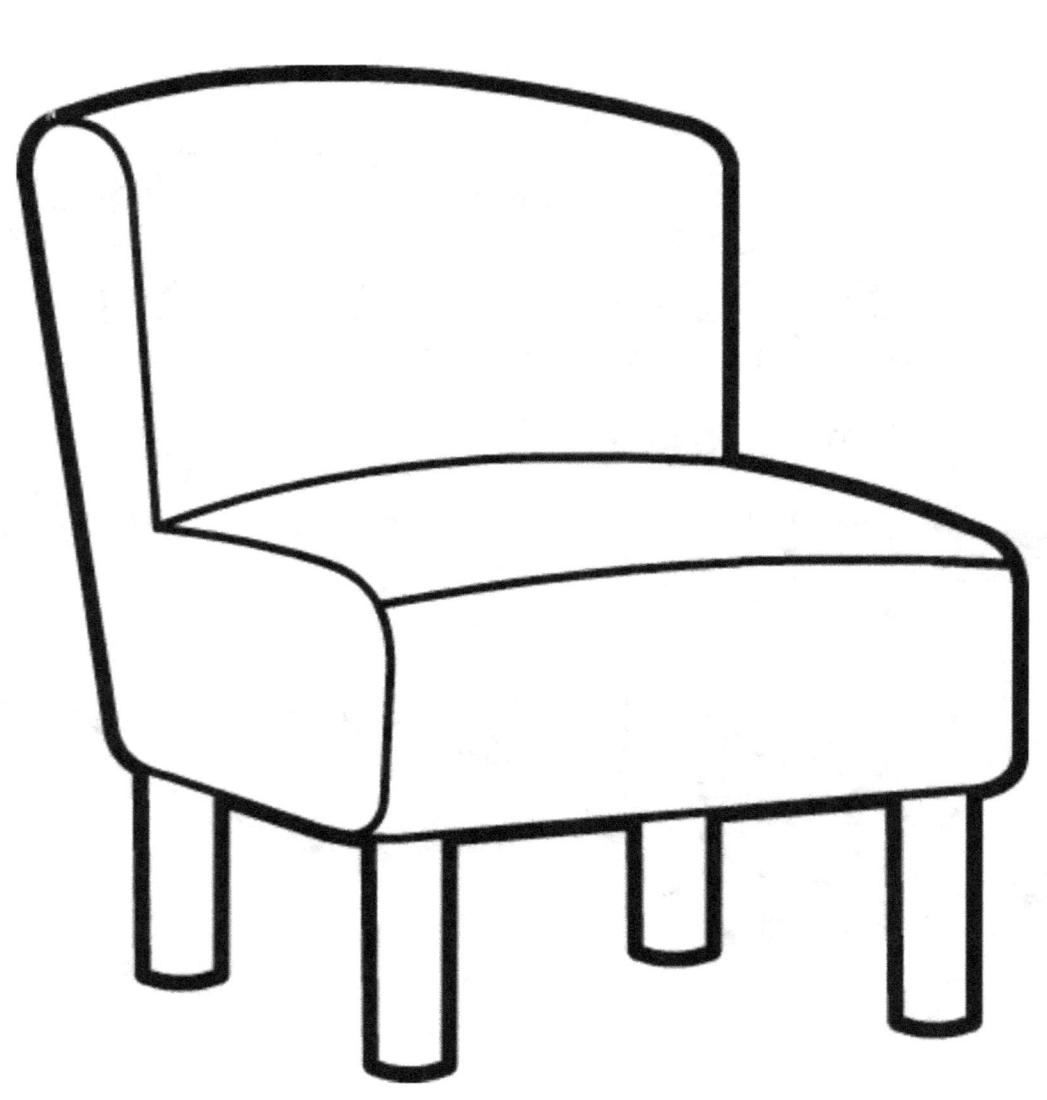

Mug

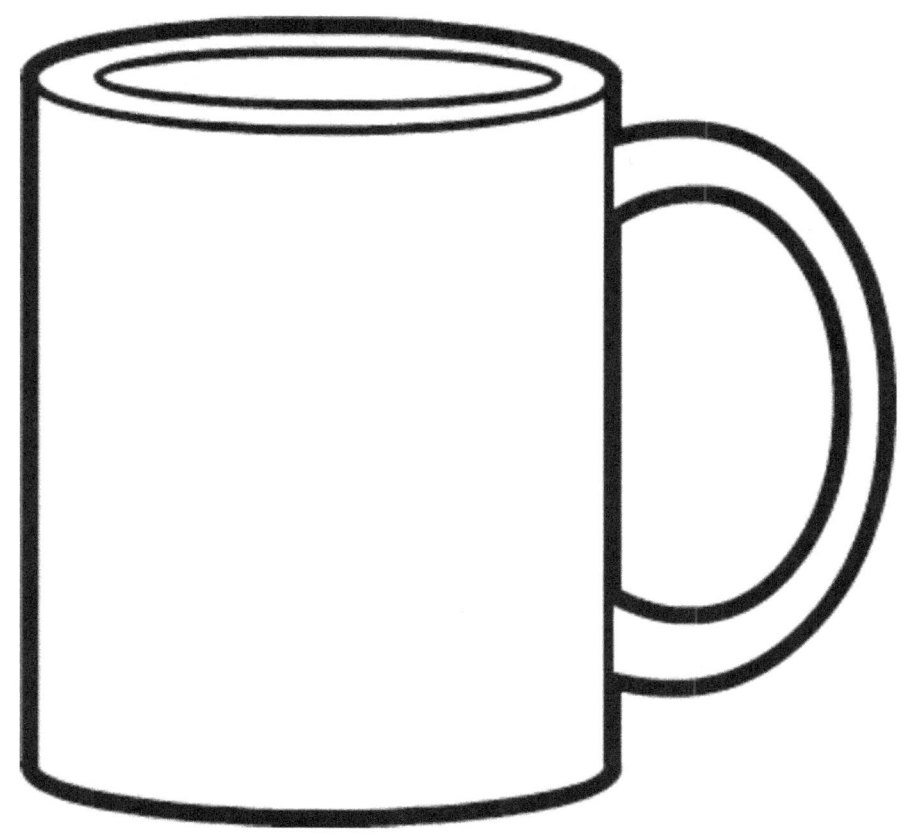

www.ingramcontent.com/pod-product-compliance
Lightning Source LLC
Chambersburg PA
CBHW081707220526
45466CB00009B/2905